Step-by-Step
Beadwork

Michelle Powell

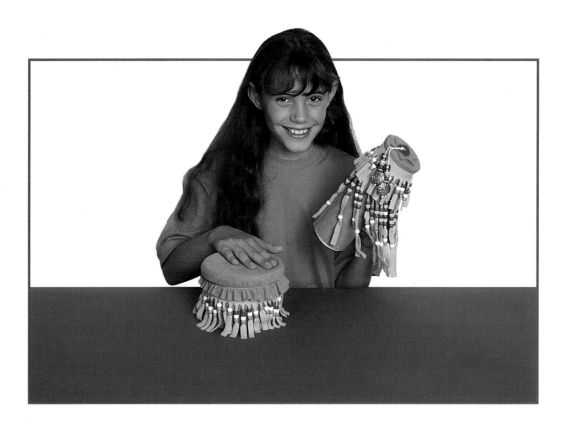

Search Press

First published in Great Britain 2002

Search Press Limited
Wellwood, North Farm Road,
Tunbridge Wells, Kent TN2 3DR

Reprinted 2002, 2004, 2005

Text copyright © Michelle Powell 2002

Photographs by Charlotte de la Bédoyère,
Search Press Studios
Photographs and design copyright © Search Press Ltd, 2002

ISBN 0 85532 979 3

Suppliers
If you have difficulty in obtaining any of the materials and
equipment mentioned in this book, then please visit the
Search Press website for details of suppliers:
www.searchpress.com

Alternatively, you can write to the Publishers at the
address above, for a current list of stockists, which
includes firms who operate a mail-order service.

Acknowledgements
The Publishers would like to thank The Bridgeman Art
Library for permission to reproduce the photograph on
page 5.

Printed in China by WKT Company Ltd

This book is for Zac.

*Special thanks once again to Mum and Dad
for their hard work and encouragement,
thanks to all the children involved, and to
the staff at Search Press.*

*The Publishers would like to say a huge
thank you to Ellie Hayward, Jacklyn Kwan,
Jessica Andrews, Rosie Watkinson,
Kawsar Ali, Emma Arditti, Luke Abrahams,
Isaac Holman and Jay Holman.*

*Finally, special thanks to Southborough
Primary School, Tunbridge Wells.*

When this sign is used in the
book, it means that adult
supervision is needed.

REMEMBER!
Ask an adult to help you
when you see this sign.

Contents

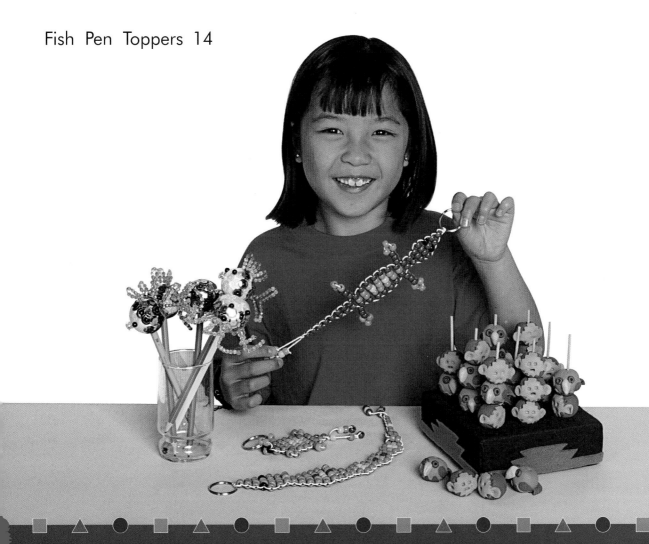

Introduction

Beads have been used for thousands of years in many different countries around the world. The earliest beads were found in the tombs of ancient Egyptians, and were made from semi-precious stones, shells, bone and gold. Beads were used not only as personal decoration but also as money. It became popular for people to carry their money beads on a string around their neck, to keep the beads safe, and to show how wealthy and important they were.

Certain types of beads also showed a person's religious or superstitious beliefs. The word bead comes from the Anglo-Saxon 'bede', meaning 'prayer'. People of many religions carry strings of rosary beads, each bead representing a prayer or psalm. Some people carry a talisman – a carved stone or other small object – believing that it will ward off evil spirits. Others wear a lucky charm, hoping that it will bring them good fortune.

Later, metal coins were used as currency. Some countries still have holes in their coins so that they can be strung together and worn as a necklace. Beads are now more normally used to make attractive jewellery and in craft projects like the ones in this book.

There are many different types of beads available. Some are made from beautiful gemstones dug from the ground such as garnet, turquoise and quartz. Amber beads are made from tree resins that have hardened in the ground for thousands of years. Precious metals such as gold and silver are also made into beads. Pearls are made in an oyster shell. This happens when a tiny grain of sand gets in to the shell. The oyster surrounds it with a special substance to make it smooth.

Many beads are made from glass. They are blown into shape or cut by highly skilled craftspeople. Wood and clay are also popular materials used to make beads. Plastic beads are made in lots of shapes and colours, using moulds.

This book shows you how to make many projects using beads and beading techniques. There are patterns at the end of the book to help you, and page 28 shows you how to transfer them on to your projects. You can make some of the beads yourself from air-drying clay, felt or high-density foam. Other projects use shop-bought beads such as tiny seed beads, larger plastic pony beads and even large polystyrene balls.

Opposite *These beads and amulets were found in the tombs of ancient Egyptian pharaohs (kings). They are made from faience (a type of glazed pottery), gold and semi-precious stones. Amulets were believed to protect the wearer from evil. The turquoise beads with jackal and hawk heads are two of the sons of the god Horus. They were put in a tomb to protect the mummy.*

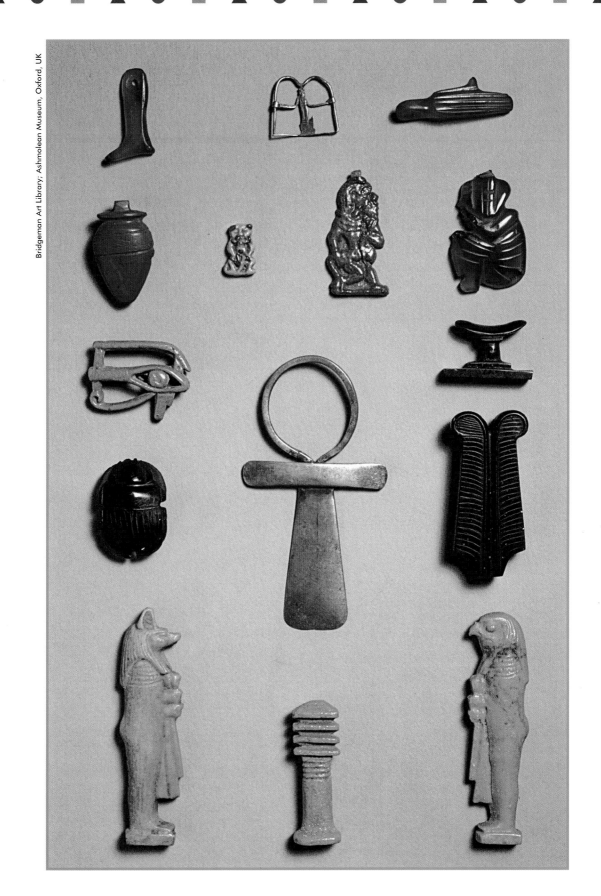

Materials

The items pictured here are the basic tools and equipment you will need to complete the projects featured in this book. You will also need card to make templates. Some of the projects involve making your own beads. Others use shop bought beads. Beads can be made from a number of different things, many of which you will have at home. Remember that whenever you use paints, glue or clay, you should cover your working area with newspaper or scrap paper.

You can make beads from **high-density foam**. Shop-bought beads include **pony beads**, **seed beads**, **bugle beads** and **faceted beads**. **Sequins** are used to decorate projects. A **split ring** is used to make the Gecko Key Ring on pages 20–21. A **bell** decorates the Indian Wall Hanging. **Window suckers** attach projects to windows.

Polystyrene balls and **blocks** are used to make large beads.

Drinking straws are used to make beads.

Cotton wool is used to stuff bead shapes.

A **clay cutting tool** is used to shape the clay beads.

A **pipe cleaner** is used to thread beads on to.

A **ruler** is used to measure and draw straight lines.

Wooden dowel is used for making puppets and beaded curtains.

You can make beads from coloured **felt**. **Fabric** can be cut into fringes and beaded.

Newspaper and a **rolling pin** are used to roll the **clay** in bead making. A **chopping board** is useful when cutting materials.

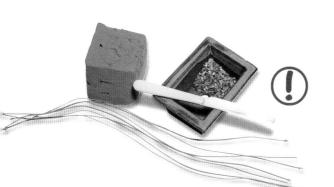

A small **plant pot**, **wire**, **gravel**, **oasis** and a **knife** are used to make the Bonsai Tree. Oasis is a type of sponge used to make flower arrangements. Ask an adult to help you cut it.

A **pencil**, **tracing paper** and **carbon paper** are used for transferring the patterns from the back of the book. You might need to go over your designs with a **felt tip pen**.

PVA glue and fabric glue are used to stick beads, felt and sequins in place. Brown **flower tape** is used to wrap wire for the Bonsai Tree. **Masking tape** is used when transferring a design.

A crisps **pot** is used as the base for the Native American Shaker.

Kebab sticks are used for piercing holes, and for hanging strings of beads.

Water-based **acrylic paints** or **poster paints** and a small **paint brush** are used for the projects in this book.

Scissors are used to cut string, felt and foam. **Old scissors** are useful for cutting thin wire. **Pinking scissors** are used to cut felt to make patterns on some beads.

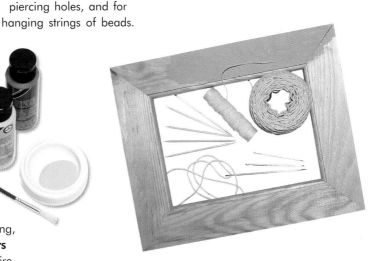

String and **elastic thread** are used to thread your beads on to. **Darning needles** and other **large needles** such as **bodkins** are useful for threading and for piercing holes. The **wooden picture frame** is to decorate with beads. **Cocktail sticks** are used to position tiny beads.

Bonsai Tree

In Japan, the art of growing tiny trees in shallow pots is called Bonsai. You can make your own miniature Bonsai trees, using sequins shaped like leaves and flower beads fastened on to wire branches. Fix the trees in some oasis and put them in small pots on your windowsill. You could make this spring tree covered in pink blossom, or use leaf beads or sequins in oranges, browns and reds for an autumnal tree.

YOU WILL NEED

30 pieces of wire, 23cm (9in) long
Some extra wire
Flower beads • Leaf sequins
Oasis • Brown flower tape
Small plant pot • Chopping board
Old scissors • Knife • Ruler
Fine gravel • PVA glue

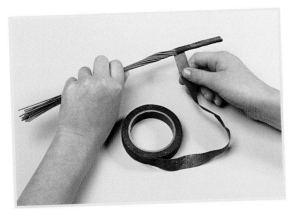

1 Using old scissors, cut thirty pieces of wire, 23cm (9in) long. Twist them together to half way along their length. Wrap brown flower tape around the twist. This makes the trunk of the tree.

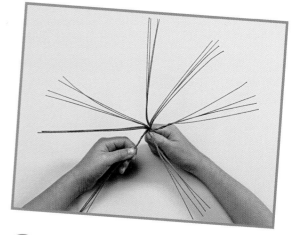

2 Split the bunch of wires into seven groups. Each group will make a branch of the tree. Twist the wires in each branch together to about half way along the branch.

(!) Ask an adult to help you to cut the wire.

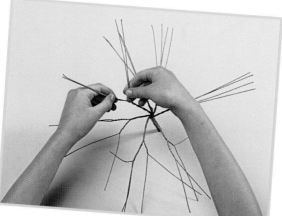

3 Divide each branch into two smaller branches. Twist the wires of the smaller branches together for a few centimetres. Leave wires sticking out in a 'v' shape at the end of each branch like twigs.

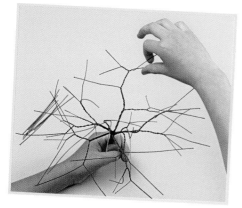

4

Ask an adult to help you to cut fourteen 5cm (2in) lengths of wire, using old scissors. Add them to the 'v' shapes at the ends of your branches. Twist them together with each side of the 'v', to thicken your twigs.

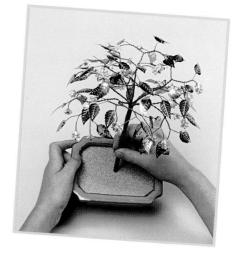

5

Take a flower bead and push a wire 'twig' through the hole. Push the bead 1cm (½in) down the twig. Bend back the end of the wire towards the centre of the flower. Now push a leaf sequin 1cm (½in) down another twig. Bend the wire over the top of the leaf and tuck it in round the back. Decorate the whole tree with flowers and leaves.

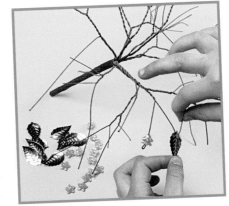

6

Using a knife and a chopping board, carefully cut oasis to fit your pot and push it in. Push in your bonsai tree. Cover the top of the oasis with PVA glue, and sprinkle on gravel.

Ask an adult to help you to cut the oasis.

FURTHER IDEAS
Make a bonsai garden, or make a partridge from card and put it in a pear tree for Christmas.

Indian Wall Hanging

Traditional Indian clothes are made from bright fabrics in beautiful colours, often with shimmering metallic threads. This wall hanging is like an Indian decoration with its bright colours and shiny sequins. The stuffed felt beads are in the shape of birds, which often appear in Indian art and crafts. The small beads are rolled from strips of felt and decorated with felt in contrasting colours. Straws are used to make good holes through the beads so that they are easier to string together.

YOU WILL NEED

Felt • Bell • Ruler
Fabric glue • Drinking straws
Pinking scissors • Felt pen
Cotton wool • String
Sequins • Carbon paper
Tracing paper • Card • Pencil
Masking tape

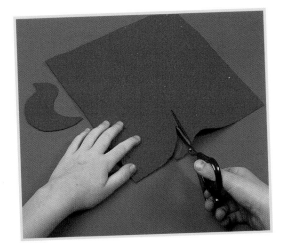

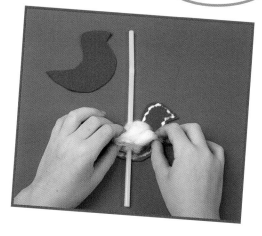

1 Transfer the bird design on page 29 on to card. Cut out the shapes and draw round them on felt, using a felt pen. Cut out two body shapes (front and back) and two wings for each bird. The wings should be in a contrasting colour.

2 Put a line of fabric glue around the edge of one back body piece. Lay a straw on the felt, and put cotton wool on top.

3

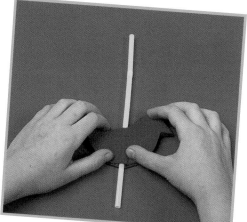

Push a front body piece on to the glue so the two halves of the bird stick together. Repeat steps 1–3 for four more birds.

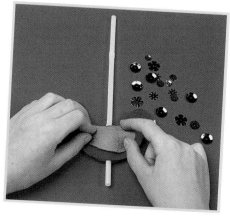

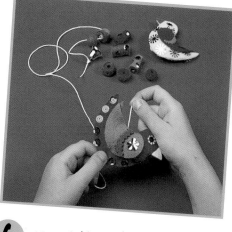

4

Glue different coloured wings on to each bird. Glue on small triangles of yellow felt for beaks. Glue on sequins for decoration. Cut off the excess straw close to the felt.

5

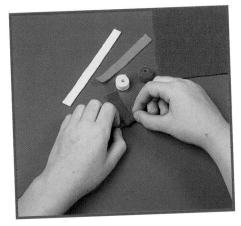

Cut thirteen strips of felt, 8cm (3¼in) long and 1cm (½in) wide. Cover one side with fabric glue and roll them around a straw to make felt beads. Leave to dry and then cut off the excess straw close to the felt.

6

Use pinking scissors to cut strips of felt 5cm (2in) long and 5mm (¼in) wide. Glue them around your felt beads for decoration. Tie a bell on to a 60cm (23½in) piece of string. Push the string through the straws inside two felt beads. Next, thread a bird on to the string in the same way, then two more felt beads. Carry on until all the birds are on the string, then add three beads at the top.

FURTHER IDEAS

Design your own Indian style wall hanging using an elephant shape instead of a bird.

Egyptian Picture Frame

King Tutankhamen was a famous Egyptian pharaoh. After he died, a beautiful mask was made of his face and buried with him in his pyramid tomb. More than three thousand years later, archaeologists discovered this mask and many other buried treasures, which were signs of his wealth and importance as a leader. This picture frame uses small seed beads and long, straight bugle beads glued on to a wooden frame in a mosaic style, to create the look of King Tutankhamen's beautiful mask.

YOU WILL NEED

Wooden picture frame
Seed and bugle beads
Acrylic poster paint
Paint brush
PVA glue • Cocktail stick
Carbon paper • Tracing paper
Masking tape • Pencil

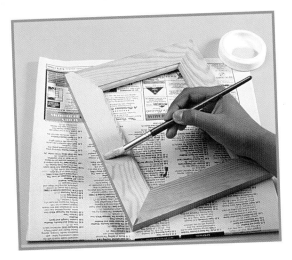

1 Paint the picture frame a pale colour, using acrylic poster paint. Leave it to dry.

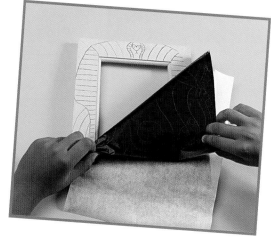

2 Transfer the design on page 29 on to the frame.

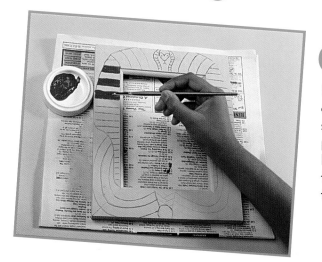

3 Paint stripes of colour on to the frame as shown. Continue painting the design, leaving blank areas for beads between the colour.

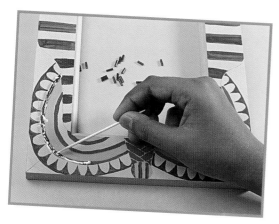

4

Paint other areas of the design as shown and leave to dry. Put a line of glue on the design. Use a cocktail stick with a blob of glue on the end to pick up the long coloured bugle beads. Position the beads along the glued line.

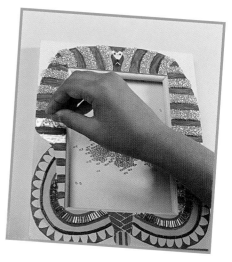

5

Squeeze a thin layer of glue on to the unpainted semicircles at the bottom of the frame. Arrange the long gold beads, using the cocktail stick as before. Add glue to the unpainted striped areas and sprinkle on gold seed beads.

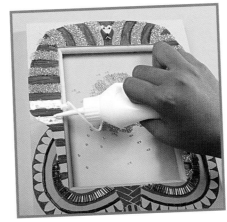

6

Press down the gold seed beads. Sprinkle on more to fill any gaps and leave the frame to dry.

FURTHER IDEAS
Design your own frame, and put in a picture inspired by the ancient Egyptians.

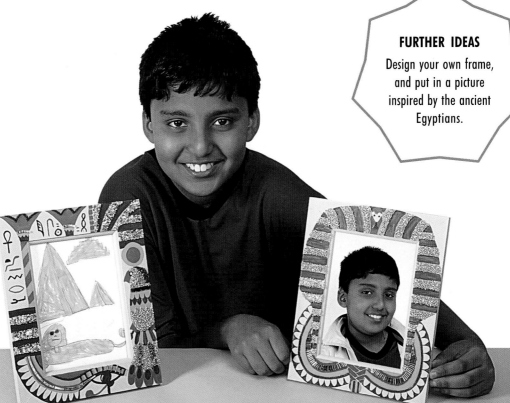

Fish Pen Toppers

Decorate your pens and pencils by making beaded fish and octopus toppers. The fish are made from a polystyrene ball, and sequins are used to look like the fish's scales. Small plastic faceted beads are used to make the fins and tail. Faceted beads are cut to have many flat faces or facets, like diamonds. This will give a shimmery feel to your fish. You could find some pictures of fish to copy or just use your imagination to create colourful fishy friends.

YOU WILL NEED

Pencil to decorate
Sequins • Beads
Thin wire • PVA glue
4cm (1½in) polystyrene balls
Scissors • Old scissors
Darning needle
Ruler

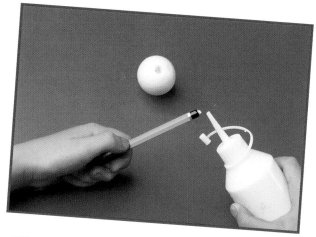

 Use the pencil to make a hole in the polystyrene ball.

 Glue the ball to the top of the pencil using PVA glue. Leave to dry.

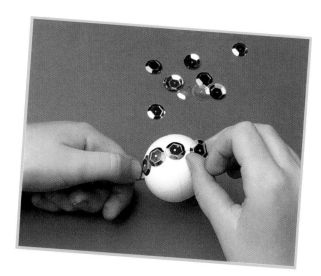

3

Glue on a stripe of coloured sequins from the pencil hole, up and over the polystyrene ball and back to the pencil hole. Cover half of the ball with coloured sequins in the same way, and the other half with clear sequins. These will make the fish's face. Leave to dry.

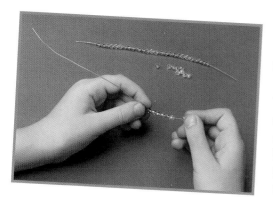

4

Using old scissors, cut two 18cm (7in) lengths of wire. Thread twenty-five beads on one for the tail and twenty-five on the other for the fin. Bend the beaded wires into tail and fin shapes like those shown in the pattern on page 31.

⚠ Ask an adult to help you to cut the wire.

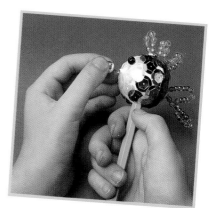

5

Make two holes in the ball with the darning needle where you want to add the fin. Put a blob of glue on each hole. Take the beaded fin and push one end of it into each hole. Do the same for the tail.

⚠ Ask an adult to help you to use the darning needle.

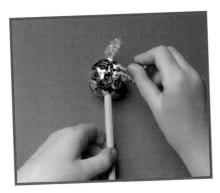

6

Place a blob of glue on either side of the face for the eyes and in the centre for the mouth. Push a black bead on to the glue for the eyes, and a clear bead for the mouth.

FURTHER IDEAS
Make beaded fish without the hole for a pencil. Attach magnets to the side to make fridge magnets.

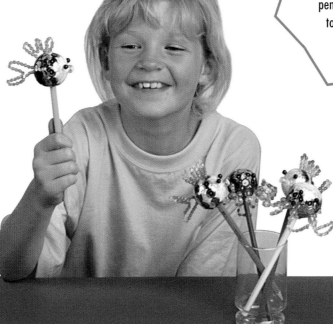

African Beaded Curtain

The shapes and colours of this beaded curtain are taken from designs used to decorate African pottery. The leaves and curling vines look like the hanging canopy found in African forests. The beads are made from foam shapes and coloured drinking straws. Hang the curtain in the doorway of your bedroom, to give it an African theme.

YOU WILL NEED

High-density foam
Scissors • Large needle (bodkin)
Acrylic poster paint • Paint brush
Drinking straws • String
Pencil • Masking tape • Card
Tracing paper • Carbon paper
Wooden dowel the width of
your door

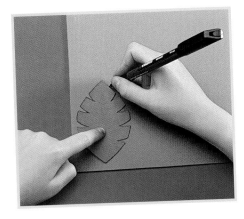

1 Transfer the patterns from page 30 on to card. Cut out leaf, triangle, star, zigzag and diamond templates. Draw round the templates on coloured foam.

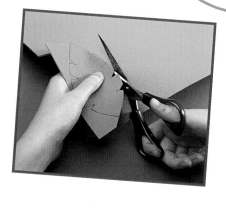

2 Cut out eleven of each shape from the different coloured foam. Cut out eleven foam strips 30 x 2cm (11¾ x ¾in).

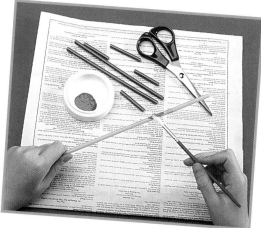

3 Paint the straws and cut them into various different lengths.

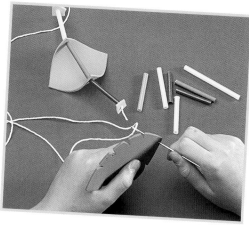

4 Cut the string into seven 2m (6½ft) lengths and thread one length on to the bodkin. Thread one end of a shape on to a string. Thread on a short piece of coloured straw, then thread on the other end of the shape. Thread a piece of straw in between each shape. Continue threading the shapes in this way.

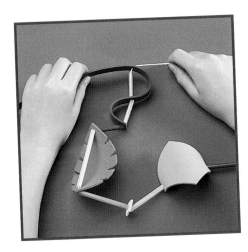

5 To thread the strips, make a small mark on the strip every 6cm (2¼in). Starting at one end, thread the needle and string through the strip, then through a short piece of straw, then again through the strip. Repeat to the end of the strip.

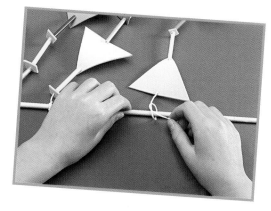

6 Thread shapes and straws on to all the strings. Tie the end of each string on to the dowel. The curtain is now ready to put up in your doorway.

Ask an adult to cut the dowel to the right length, and to hang the finished curtain for you.

FURTHER IDEAS
Decorate a foam band and put it round your head to make an African headdress.

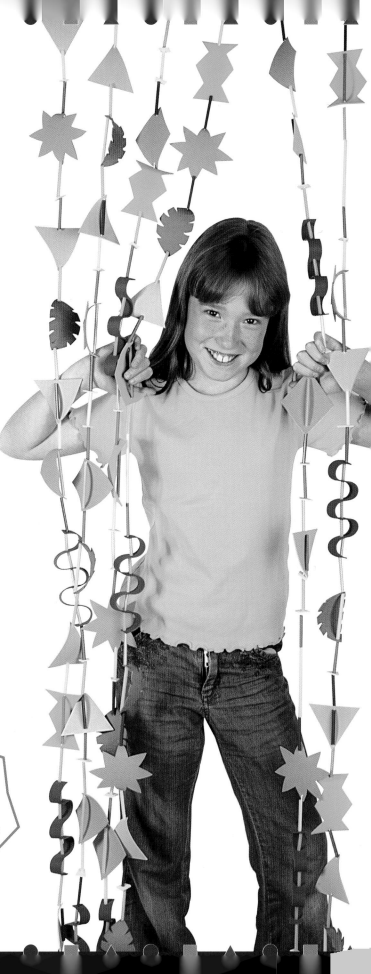

Native American Shaker

Native Americans often made clothes and bags with a beaded tassel trim. Animal hide was cut into strips and threaded with beads for decoration. This shaker is made in a similar way, using felt cut into tassels, with pony beads threaded on to make a design. The felt is wrapped around a pot filled with more beads so that you can make music.

YOU WILL NEED

Crisps pot to decorate
Pony beads and decorative beads
String • Scissors • Ruler
Felt tip pen • PVA glue
Light coloured fabric
Coloured felt

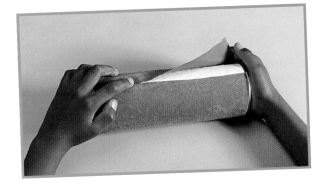

1 Cut a piece of fabric large enough to fit round the crisps pot. Cover the pot with PVA glue and leave until it is tacky. Glue the fabric on.

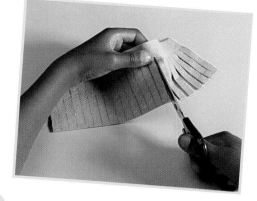

2 Cut two strips of felt, one 7cm (2¾in) wide and the second 18cm (7in) wide. Both must be long enough to go round the crisps pot. Draw lines 1cm (½in) apart on the strips. Cut fringes as shown, using the lines as a guide and cutting to 2cm (¾in) from the top.

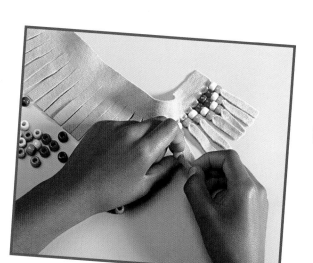

3 Thread beads on to the fringe of the smaller strip as shown, to make a pattern. Decorate the other fringe in the same way.

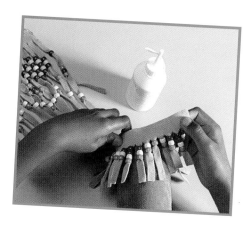

Glue the long fringe around the pot so that the tassels hang to the bottom of the pot. Glue the short fringe around the pot near the top.

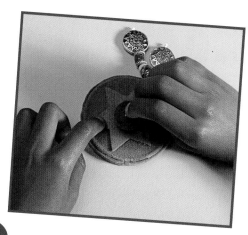

5

Put any leftover beads into the pot to make the shaker noise.

6

Draw round the lid and cut out a circle of felt. Glue it on to the lid. Add a turquoise trim. Transfer the star and circle patterns on page 29 on to felt and cut them out. Stick the star on to the lid. Thread some decorative beads on to two 10cm (4in) pieces of string. Snip a tiny hole in the middle of the circle. Push the ends of the strings through the hole and glue the circle on top of the star.

FURTHER IDEAS

Make a fringed drum from a plastic tub to go with your shaker.

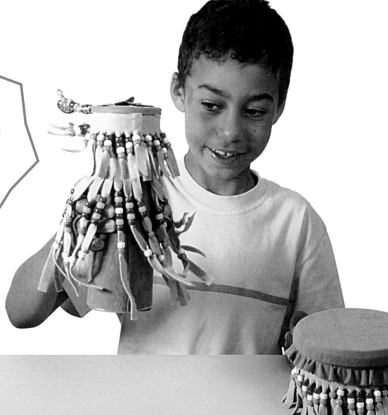

Gecko Key Ring

Geckos are lizards that live in warm countries. Their feet stick to smooth surfaces, so that they can run up walls and even across ceilings! These cute gecko key rings are great fun to make. Coloured pony beads are threaded on to string to form the shape of the gecko. You could use any beads, but make sure that the string you are using will pass easily through the bead hole twice. This technique is ideal for making reptiles like snakes, frogs or turtles, because the beads look like the patterns on scaly skin.

YOU WILL NEED
Eighty-five pony beads
Split ring
String
Scissors

1 Cut 1m (39½in) of string. Fold it in half and loop it through the split ring. Push the two ends of the string through the loop and pull tight.

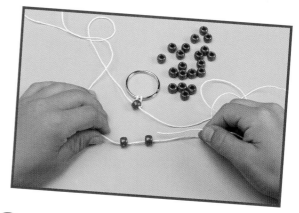

2 Look at the pattern on page 31. Thread one bead on to one of the strings, then push the other string through the bead in the opposite direction. Push the bead right up to the ring. Next thread two beads on to one string and thread the other string through in the opposite direction. Push both beads tight against the first bead.

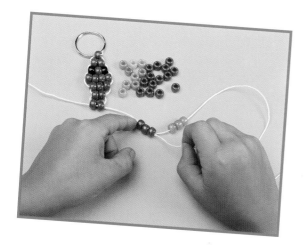

3 Continue following the pattern to make the gecko's head. Push the beads tight against each other after threading each row. To make the first leg, thread three dark and three light coloured beads on to one string. Bring the string round and thread it back through the dark beads.

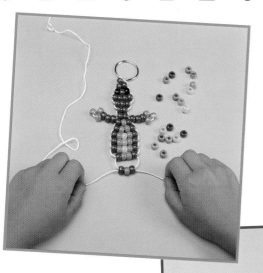

4

Make the second leg on the string on the other side. Now continue with the body, following the pattern. Pull the strings tight after threading on each row of beads.

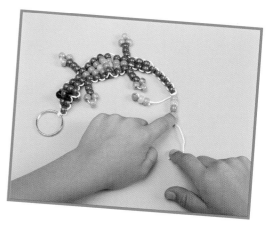

5

Make the gecko's back legs in the same way as the front legs. Next thread two beads on to the string on one side, and then thread the other string through the beads in the opposite direction. Continue following the pattern in the same way to make the tail.

6

Tie off the strings together at the end of the tail. Now thread three more beads on to each remaining length of string, for decoration. Knot and cut off both strings.

FURTHER IDEAS
Make zip pulls or a mobile with your beaded creatures, or use glow in the dark beads to make aliens or ghosts!

Rainbow Sun Catcher

This sun catcher's pattern is in the shape of a traditional stained-glass window. The stained-glass windows in churches show scenes from the Bible. In times when many people could not read, preachers used them to teach people about Bible stories. For this sun catcher, you need pony beads that are coloured but transparent, so that the light will shine through them, as well as some opaque beads. The beads are threaded on to strings, so that when they are hung together, they will form a picture of the sun rising, a rainbow and a moonlit sky, all in a window frame. Stick your sun catcher to your window, and wait for some sunshine to bring it to life!

YOU WILL NEED
Black and metallic opaque pony beads
Clear, coloured pony beads
A kebab stick
Three window suckers
Ruler • Scissors
String

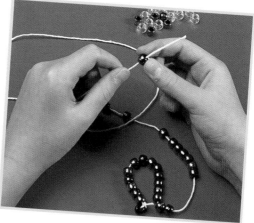

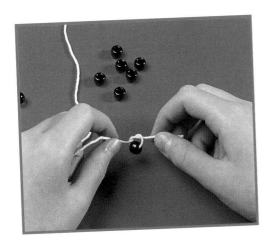

1 Cut twenty-four lengths of string, 50cm (20in) long. Tie a black pony bead to one end of twenty-three of them. Tie an opaque metallic bead to the end of the other one. Pull the knots tight.

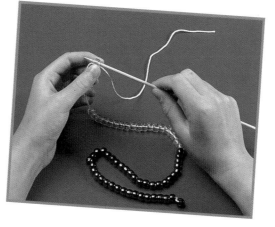

2 Look at the pattern on page 31. Using the first string, thread the opaque metallic beads and the clear beads in column one. Thread the last clear bead on to the string.

3 Now thread this last clear bead on to the kebab stick. Tie the string round the kebab stick and cut off the end of the string.

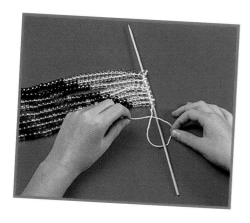

4

Carry on threading beads on to the strings, one column at a time, following the pattern. Push the kebab stick through each final bead and tie the string round the kebab stick as shown.

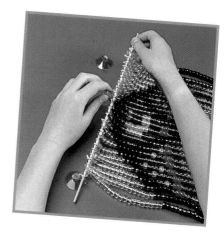

5

Continue following the pattern, tying off the ends and cutting off the excess string.

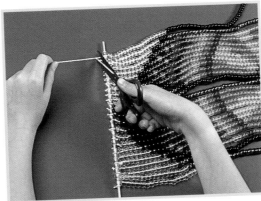

6

Hook three window suckers on to the kebab stick. Now the sun catcher is ready to be attached to your window.

FURTHER IDEAS

Add bells to the bottom of the sun catcher and hang it up to make a wind chime.

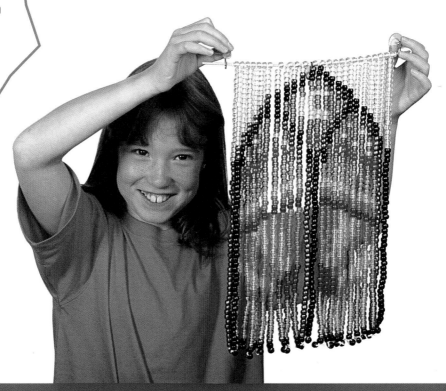

Astronaut Puppet

Polystyrene balls can be used as huge beads and strung together to make an astronaut puppet wearing a space suit. You will need polystyrene balls in the following shapes and sizes: two 8cm (3¼in) egg shapes for the hands; two 10cm (4in) egg shapes for the feet; one 9cm (3½in) ball for the head; one 11cm (4¼in) ball for the body; two 6cm (2¼in) balls for the shoulders; four 8cm (3¼in) balls for the legs, and four 7cm (2¾in) balls for the arms and legs.

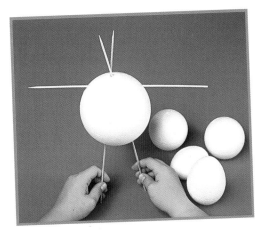

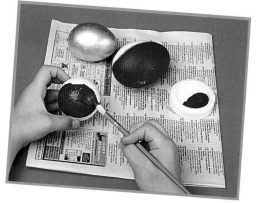

1 Use a kebab stick to push a hole straight through the middle of all the polystyrene balls except the body. Make three holes in the body as shown, and then pull out the kebab sticks.

Ask an adult to help you to make holes with the kebab sticks.

2 Paint two of the egg shapes as gloves, and the other two as space boots. Paint the details of the face and helmet and the body. Paint the polystyrene block. This will be the astronaut's oxygen tank.

3

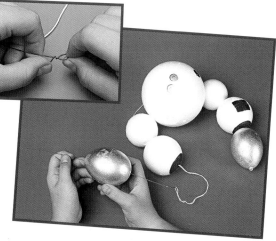

Make a long needle by twisting the end of a piece of wire as shown. Thread it with elastic thread. Tie a knot, then thread on a small bead, a glove, two arm beads, the body and then another two arm beads, the other glove and a second small bead. Then tie another knot.

Thread another piece of elastic thread through a small bead, a boot and three leg beads. Push the needle up through one of the body holes, then down through the second hole. Thread on three more leg beads, a boot and a bead, and tie a knot.

4

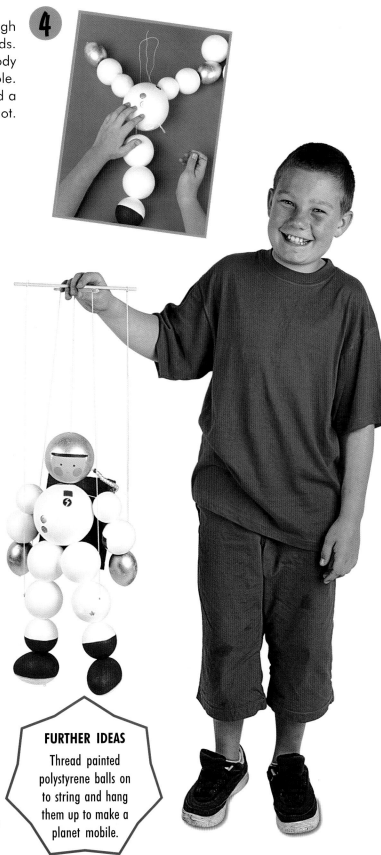

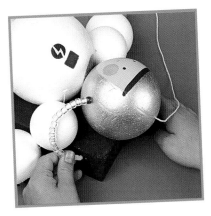

5 Thread a piece of elastic thread down through the head bead and tie it to the loop left by the legs. Stick the oxygen tank to the body using PVA glue. Thread some clear beads on to a pipe cleaner, and push one end in the helmet and the other end in the oxygen tank.

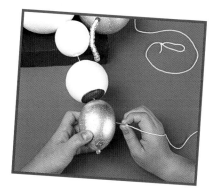

6 Make small wire hooks and stick them in the knees and hands, then tie on four lengths of string 75cm (29½in) long. Tie the other ends to the two pieces of wooden dowel, tied in a cross shape. Put another wire hook in the head, and use string to attach it to the centre of the dowel cross.

FURTHER IDEAS
Thread painted polystyrene balls on to string and hang them up to make a planet mobile.

Aztec Game

The Aztecs lived in Mexico around five hundred years ago. They were warlike people but they also made amazing art and crafts. They carved the shapes of faces and animals in to tall wooden poles, to make sculptures. This game is based on Aztec sculptures. The playing pieces are large clay beads in the shapes of birds and faces. You need fourteen birds and fourteen faces to play three-dimensional noughts and crosses.

YOU WILL NEED

Air-drying clay
Rolling pin • Clay cutting tool
Ruler • Drinking straw
Acrylic poster paint • Paint brush
Nine pieces of thin wooden dowel
15cm (6in) long
Block of polystyrene 16cm (6¼in) square
PVA glue • Felt, two colours
Tracing paper • Carbon paper
Card • Scissors • Pencil
Masking tape

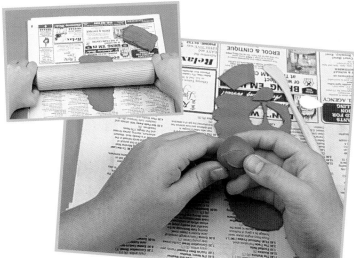

1 Transfer the tail, feet and wing patterns on page 30 on to card and cut them out to make templates.

2 Roll twenty-eight balls of clay the size of a walnut in your hands. Use the straw to make a hole through the middle of each ball.

3 Roll out a piece of clay about 4mm (⅛ in) thick and use the templates to cut out wing, feet and tail shapes for the birds. Stick these to fourteen of the clay beads.

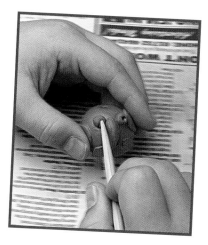

 4

Roll balls for the eyes. Press them on to the clay beads, using a little water to help them stick. Use a clay cutting tool to indent the eyeballs and make grooves in the wings and tails. Leave to dry.

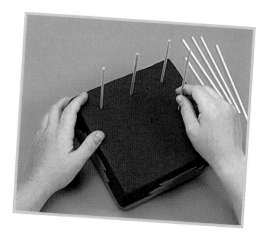

 5

Paint the fourteen bird beads and leave them to dry. Now make fourteen Aztec face beads using the face pattern on page 30. Paint them, too.

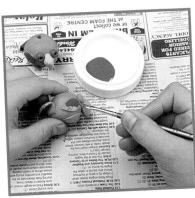

6

Take the square of polystyrene and cover it with felt. Use the pattern on page 30 to make a felt decoration for each side. Push the pieces of dowel into the square in evenly spaced rows of three. Now you can play three-dimensional noughts and crosses with the birds and face beads – any straight line of three beads wins!

FURTHER IDEAS
Make a draughts board from card and use your beads to play draughts.

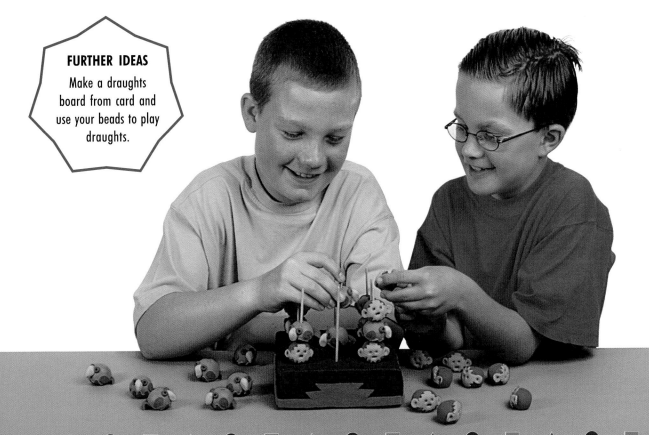

Transferring Patterns

You can trace the patterns on these pages straight from the book (step 1). Alternatively, you can make them larger or smaller on a photocopier if you wish, and then follow steps 2–4 to transfer them on to your project.

Get an adult to help you enlarge the patterns on a photocopier.

1 Place a piece of tracing paper over the pattern, then tape it down with small pieces of masking tape. Trace around the outlines using a soft pencil.

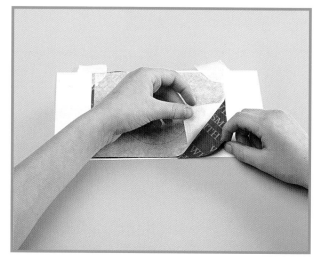

2 Place the tracing paper or photocopy on the surface of the project and tape it at the top. Slide the carbon paper underneath and tape it at the bottom.

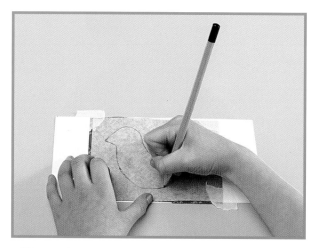

3 Trace over the outlines with the pencil, pressing down firmly.

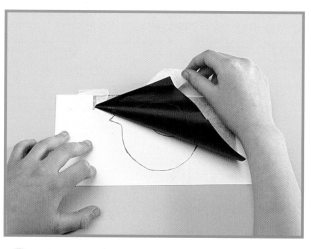

4 Remove the tracing paper, and the carbon paper, to reveal the design.

Patterns

Patterns for the Indian Wall Hanging featured on pages 10–11

Patterns for the Native American Shaker featured on pages 18–19

Pattern for the Egyptian Picture Frame featured on pages 12–13

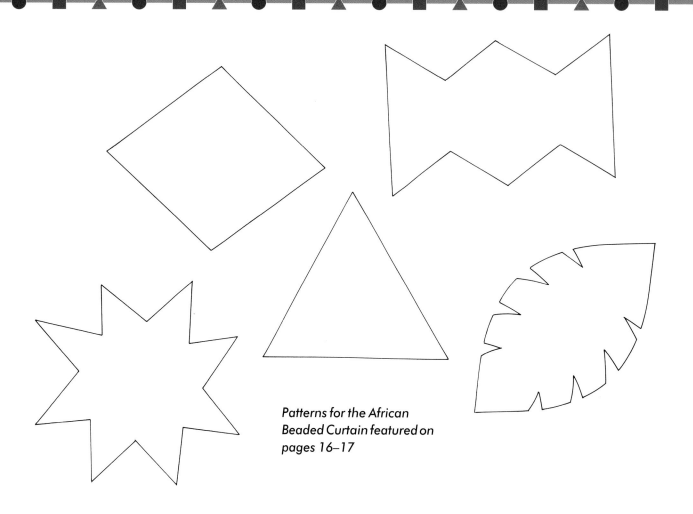

Patterns for the African
Beaded Curtain featured on
pages 16–17

Patterns for the Aztec Game featured on pages 26–27.
Top left to right: tail, feet, wing and face patterns. Bottom:
felt decoration for the base.

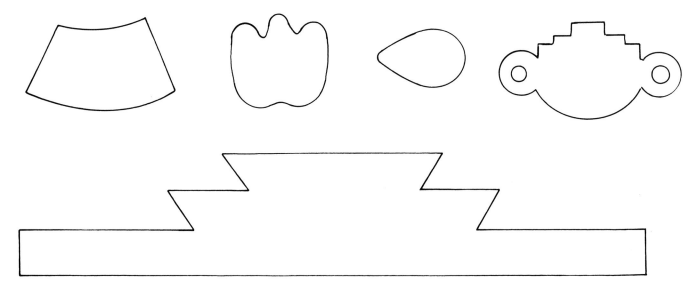

Pattern for the Rainbow Sun Catcher featured on pages 22–23

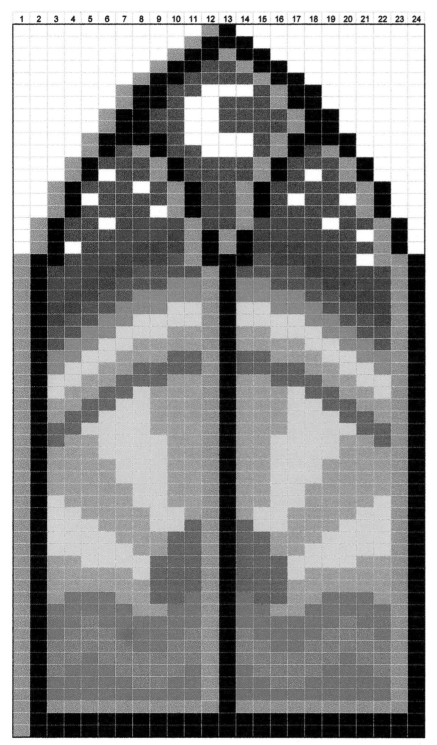

Patterns for the Fish Pen Toppers featured on pages 14–15

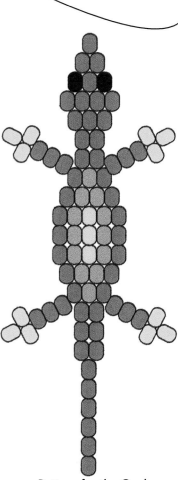

You will need: 237 opaque black beads; 190 opaque metallic beads (shown as grey); 128 clear turquoise beads; 68 clear red beads; 90 clear green beads; 194 clear orange beads; 140 clear yellow beads; 32 clear purple beads; 34 clear pink beads; 95 clear blue beads and 208 clear colourless beads.

Pattern for the Gecko Key Ring featured on pages 20–21

Index